Lesley Lawson

PHAIDON
non mint copy

D0391037

LAW

GOLDBLATT 55

NOV 1 4 2014

Φ

David Goldblatt, South Africa's foremost documentary photographer, was born in 1930 and grew up in Randfontein, a small town outside Johannesburg. His father owned and ran a shop, as did his father before him. Randfontein was an unremarkable town, surrounded by gold mines, and beyond them, the plots or smallholdings of working-class Afrikaners. The biting August winds blew mine dust through the streets, and after winter fires the blackened grass crunched underfoot. The days were punctuated by the hooters that signalled the shift change on the mines. At night, distant lights illuminated the shapes of men labouring on the mine dumps. Each morning, the police marched handcuffed black people across the town, who had broken one of the many small, incomprehensible laws. It is the particularities of these origins that have informed Goldblatt's photography. Unlike many documentary photographers, who have sought to explore the unknown, to document dramatic moments in the lives of strangers, Goldblatt has mined a deep vein of personal experience – not in the style of 'confessional' photographers who use themselves and their nearest as subjects, but as a relentless probe into the layered substructure of his place and time.

Goldblatt's fascination with photography began with the picture magazines of the 1940s and 1950s – *Look*, *Life*, *Picture Post*. When he left school, he took a job with a local photographer. During the week, he assisted in the darkroom; at weekends they photographed weddings. Goldblatt's job was to identify any guest using an expensive camera and bump him. His humiliation increased when he learned that the small salary he received was actually paid by his father.

Attempts to establish himself as a magazine photographer were thwarted by his lack of skill and experience, and also his unwillingness to

record those moments of high drama in which the media then were most interested. When his father became ill, Goldblatt had to take over the family business; for ten years he managed the shop while studying part time. In his free time, he made photographs. A key moment in his development as a photographer came while he was photographing places of worship. Until then, he had lusted after the rich tones and gentle gradations of the European print; now he realized that the intensity of the Highveld light was integral to his sense of place, and began to work within it. This savage, cutting light creates blinding highlights and sharp slabs of deep shade. Hostile to those who are unaccustomed to its ferocity, it can be tamed to reveal the sweetest secrets.

Goldblatt's early years as a photographer coincided with the new apartheid government's rise to power. As the demagogues unfurled their plans for South Africa's destruction, black people resisted with mass campaigns of boycott and defiance. Goldblatt's abortive attempts to document this forced him into an early understanding that he would not find meaning in the big events, the public face of brutality and violence. Instead, he sought out the world of ordinary people, the minutiae of everyday life that so illuminate the deep structure of injustice and the essence of the people who imposed and defied it.

Through his work in the shop, Goldblatt became intrigued by the Afrikaners whom, as a schoolboy, he had learned to hate and fear for their bullying racism and anti-Semitism. Close-up, however, some were warm people, and in spite of himself, he enjoyed their earthy, idiomatic language. On his days off, he began driving around their plots and photographing them. He was mystified by the contradiction at the very heart of their existence – their generosity of spirit which existed side by side with a deep fear and rabid hatred of black people. A

one plot, for example, he found a family who had devoted an entire afternoon to making a coffin for a neighbour's servant, while joking about the bits of her they would chop off if her body didn't fit inside.

The 'Afrikaners' project enabled Goldblatt to define the quest that would continue to underlie his work throughout his career – an understanding of the human values that determined and moulded his strange place of belonging. In his words: 'I wanted to grasp something of what a man is, and is becoming, in all the particularity of himself and his bricks and bit of earth ... and to contain all of this in a photograph. To do this, and to discover the shapes and shades of his loves and fears, and my own, would be enough.'

Work on this project continued for several years. For the first time, he received some recognition when these photographs were published in *Camera* and other international magazines. Encouraged, he took a dummy of a book abroad in search of a publisher. It was not a constructive experience. In Britain he was told to find a co-publisher in America, and in America he was told 'you ain't got a gimmick'. He recalls this as a time in which he seriously thought of suicide.

On his travels, Goldblatt met the photographer Paul Strand. Almost blind, Strand seemed to read the photographs with his fingers. He liked the work, but asked Goldblatt, 'What has happened to your skies?' Goldblatt explained that the brightness of the African light led to a lack of tone in the highlights of his prints. Discovering that Goldblatt had an enlarger with a cold-light head, which facilitates the printing of high-contrast negatives, Strand said 'Go home and use it.' In this way, Goldblatt found the solution to the problem. Seven years later, *Some Afrikaners Photographed* was published by a friend who

thought it an important body of work. The Afrikaners themselves, however, could not accept the mirror that he held up to them. His critics were unable to relate to the nuances and layers of Afrikaner life that this work revealed. Goldblatt was hurt by the response. 'I found it difficult to convey that I saw beauty, and that my photographs, though critical, were full of love,' he recalls.

In parallel with *Afrikaners*, Goldblatt was exploring the goldmines of the Witwatersrand. At this time, many of the mines were closing under economic pressure. The great machinery, wide landscapes and heroic figures of his childhood were under threat, and Goldblatt felt that he had to record this passing world on film, even if only for himself. With the writer Nadine Gordimer, he collaborated on a project that was published by a local magazine, *Optima*, and later expanded into the book *On the Mines*, published in 1973. It was the first of several collaborations between the two. Thirteen years later, they produced *Lifetimes: Under Apartheid*, a project that wove Gordimer's words and Goldblatt's images into a rich vision of their place and time. The book begins with a joint statement: 'We have come a long way, with our country: a lifetime. Both of us were born white and slowly learned to leave that fatal isolation through the lessons of our work; the images and words.'

The *Afrikaners* and *Mines* projects were the first in a series of ever-widening autobiographical circles traced by Goldblatt's work. In the early 1970s, he photographed the down-at-heel inner suburbs of Johannesburg in a series of images reflecting his fascination with the hopes and dreams of others. This is a thread that runs through all his work, from the Hillbrow couple who pose their perfectly dressed baby in its cardboard suitcase crib, to the young drum majorette in her crisp uniform at the Soweto Cup Final; from the builder with

his unsteady hand-scrawled sign and mobile phone, to the teenage ballet dancer grimacing through her paces on a suburban veranda. Writer Lionel Abrahams has called these pictures 'images of aspiration'. He writes: 'The people in many of his pictures are surrounded by objects, marks, decorations that imply not only what they are, but what they have chosen to be .. Often there is a distance and a tension between present circumstances and the aspirations, an ironic incongruily, and this results in a special wry poignancy not always remote from humour.'

Goldblatt's style of portraiture never manipulates the viewer into easy emotion. He allows his subjects to present a complex view of themselves, which keeps us at a distance. Ironically, this distance seems to increase the closer we get to the subject. In the mid-1970s, he began to explore the use of detail to reveal his subjects, later exhibiting these works under the title *Particulars*. Goldblatt sees this as the first series in which he used the camera to indulge his sensual self. He stares without shame at the pores, the folds of flesh, the bulging thighs of humanity, reflecting his view that 'the ordinary is remarkable'.

In the 1970s he travelled deeper into the world of black South Africans. By now, he had established a productive relationship with *Optima* magazine, which financed his personal projects in exchange for the right to publish the photographs. He embarked on an essay on Soweto, where he spent most of his time over a six-month period. As a white man in a black township, Goldblatt was presented with a photographic challenge. He found that he could never disappear behind the lens and be forgotten. It called for a more formal approach. He was stunned by the implications of this township – these lives lived in an overcrowded dusty place at the end of a highway on which no white

people travelled. The restrictions under which people lived gave the place a strange, claustrophobic quality. At weekends, there was a palpable level of violence in the air. The photographs, however, focus on respectability and the ordinariness of life in a place of unbearable tension – a voluptuous woman against a scarred wall, children playing under a toxic sky.

In 1975 he began to work in the black rural area of Transkei, which was soon to become an 'independent' state under the apartheid government. Many of these images are of grinding poverty – the burden of survival in areas too densely crowded for even subsistence farming to be viable, where remittances from migrant workers and old-age pensions were the only income. And yet in these places there is beauty – the lush landscape, the strength of familial bonds, the dignity of age. And it is this elegiac quality that Goldblatt strives to celebrate in the rich tones and composition of his images.

Between major projects and alongside his commercial work, Goldblatt returned to a much-loved subject: Johannesburg. This was the city of bright lights to which he escaped with his camera as a teenager. Later, when Johannesburg became his home, Goldblatt would cycle through the deserted Sunday morning streets with his 4 x 5 camera, tripod, light meter and six sheets of film. During the late 1970s, many of these journeys were to Pageview, a small suburb to the west of the inner city. For many years an Indian community, the area was now designated as a white, residential area. The original inhabitants were to be moved to a new suburb 40 kilometres out of town. Goldblatt eschewed the news story in favour of images that take us right to the core of this destruction – photographs of the interiors of people's homes, which speak of permanence and the right of belonging. Sometimes, he photographed the inhabitants themselves,

but we come to know them better through the objects they have chosen and the spaces they have made. As he documented the destruction of their lives, Goldblatt befriended some of the residents. Ozzie Docrat, a shopkeeper, told him, 'I feel as though my teeth are being pulled out one by one. I run my tongue over the spaces and I try to remember the shape of what was there.'

While the apartheid authorities were relocating black South Africans to remote spots in designated areas, white towns were proliferating over the vacant land. These characterless places, with their uniform shop fronts and standard housing developments, interested Goldblatt. He wanted to understand this particularly South African form of modernity, and the way in which it related to the white, middle-class, small-town life that he had known as a child. He selected Boksburg, to the east of Johannesburg, and photographed there over the autumn and winter of 1979 and 1980. For days, he stood on street corners, parking lots and sidewalks. He recalls: 'It was as though I had known the place for a very long time and was yet discovering it for the first. The spaces and roads, and the lines painted on them; the low buildings and sky; the veld and the way the town sat on it, with the people black and white, moving in their separate but tangled ways; all of these were there to be seen in the cutting sharpness of the Highveld light.'

Through contact with a local journalist, Goldblatt was kept informed of the social diary of the town, so that he could photograph public as well as private life. Because he did not want photographic and optical effects to interfere with the sense of the subject itself – its 'middle greyness' – he deliberately restricted his photographic range, using a normal lens and concentrating on mid-grey tones. Though verging on the anthropological – concentrating on weddings,

funerals, sporting events, the rhythms of daily life – this collection of photographs, published as *In Boksburg* (1982), represents a profoundly personal view of the bleakness and ennui of South African suburban life. One can almost hear the lawnmowers, vacuum cleaners and washing machines, the shouts of domestic workers over concrete garden walls; and all of this against a broad canvas of the ideology of the era of Total Onslaught – white supremacy, segregation, the border war. The work captures the essence of Goldblatt's ambivalence – his belonging to, and alienation from, the ugliness, the impossible contradictions, of white South African life. In a later interview he said: 'I was going back to look at something very close to me, and indeed quite painful. What I was looking to do was to explore how it is possible to be decent, normal, in a situation that is in every sense mad.' *In Boksburg*, like most of Goldblatt's books, disappeared after its publication. The small publisher had no cash to spend on marketing, and was forced out of business not long after the book was completed.

As apartheid tightened its grip, Goldblatt's approach to photography was challenged by activists and young, politicized photographers. In 1982 the banned African National Congress (ANC) held an arts conference in neighbouring Botswana at which 'cultural workers' were charged with the task of converting their tools into weapons of struggle. Goldblatt openly disagreed with this approach. His respect for the complexity of his subject was paramount, and he felt that photographs made to further a political end would jeopardize this. He refused to be a propagandist even for views with which he was in sympathy. 'To me, the photographer is an observer, a passionately dispassionate observer and he must be open to the reality before him,' he commented. It was a lonely road, but Goldblatt stuck to it with determination. At various times, however, he refused commercial assignments that required a certain engagement with

the powers that be. One such incident cost him his relationship with the agency that provided the bulk of his income.

Goldblatt's relationship with the 'struggle photographers' in South Africa improved with his active participation in the Second Carnegie Inquiry into Poverty in 1983. He produced a photo-essay on the long journey undertaken by daily migrants, later published as *The Transported of KwaNdebele*. He also developed a close relationship with the young photographers who had committed themselves to a more overtly political form of photography. He gave generously of his time. Many hours were spent discussing their work, teaching basic technique, and giving printing lessons. The Goldblatt house was a welcoming place for international visitors and new photographers alike. Yet in 1985, he found himself on the cultural boycott list of the ANC abroad, who had discovered that he had done corporate work for one of the big mining houses. His exhibition was withdrawn from its engagement at a gallery in Liverpool and it took several months, and vociferous objections from ANC supporters at home, for them to reverse this decision.

Goldblatt was relatively unaffected by these goings on. He was engrossed in the project that was to be a distillation of his life's work. For twenty years, he had nurtured an intense and probing interest in the built structures, the human landscape, of his place and time. In his own words: 'Many of our structures tell much and plainly and with extraordinary clarity, not only of the quality of existence and of the needs, conceits, longings, fears of those who built and used them, but often too of vital beliefs and ideologies upon which lives here were contingent ... Our structures often declare quite nakedly, yet eloquently, what manner of people built them, and what they stood for.'

Throughout the 1980s, Goldblatt documented the structures that spoke of the forces shaping South African society from the beginning of the colonial period in 1652 to the end of white domination in 1990. He bought a camper van for the purpose, and, occasionally accompanied by his wife, Lily, covered some 150,000 kilometres in this quest. Three Christmas holidays in a row were spent outside the headquarters of the provincial government in Bloemfontein, waiting for the perfect moment to photograph a statue of Hendrik Verwoerd. Three Sinar field cameras were worn out in the course of the 'Structures' project. The 1980s were the bleakest years in South Africa's political history, when a low-grade civil war was infecting the land, children were detained, protesters beaten, arrested and killed. There were many times when Goldblatt felt that his concentration on the 'Structures' work was inappropriate. On occasion, he offered his services to political organizations that assisted victims of apartheid. But his commitment was to his own way of telling.

Many of the 'Structures' photographs are of churches and monuments built to glorify the Afrikaner state. Others document the structures erected in defiance of it, or those that were destroyed by it. A cold rage reverberates through the work. The light does not fall gently, it strikes the stone faces of the Afrikaner women and the barren brick of the Dutch Reformed Church. It lays bare the era of domination of white over black. The project culminated in the publication of 136 photographs in the book *South Africa: The Structure of Things Then* and a one-person show at the Museum of Modern Art in New York in 1998.

Integral to this project was a detailed text, presenting a finely argued case against the whole system of apartheid and its makers. This represented a

complete departure for Goldblatt. His earlier work had allowed the images to do the work, prompting the writer Lionel Abrahams to suggest that it was characterized by his desire not to 'manipulate the visible world into evidence for a case, but to allow it to yield its own meaning'.

For Goldblatt, as for other South African documentary photographers, the demise of white supremacy in 1990 meant a definitive break in his work. The old enemies were gone, and the new dispensation presented other challenges. During the early post-apartheid years, Goldblatt was preoccupied with the text of *Structures*, but on the day it was completed, he got into his car and drove from the inner city of Johannesburg to the outer reaches of its suburbs. He was appalled by what he saw of the 'new Johannesburg': 'An entire architecture, which had been devoted to a particular form of capitalism, had been subverted. Every building was hung with cheap imports from Korea and Taiwan, and herbalists' products, and was dedicated to every imaginable thing except the purpose for which it had been intended. The city had an air of devastation. Huge amounts of urban degeneration had occurred – garbage in the streets, buildings in disrepair.' On the other hand, he found the northern suburbs, to which capital had fled, had been overtaken by a manic pursuit of security and material wealth. Expensive shopping malls, walled estates and office parks had filled the space like some self-replicating virus.

Goldblatt felt estranged. He started photographing as a way of relating to these new phenomena. The work began in black and white in the inner city, which had not only changed physically, but whose entire atmosphere was different. The escalation of crime on the city streets meant that he had to hire an armed security guard to protect his equipment while he worked, and black

people were more hostile to the camera than before. Nonetheless, through these encounters, he began to appreciate the up-side of the changes. Black Johannesburgers were building their own worlds and laying claim to a city that had always been denied to them. Goldblatt was excited by the ease with which they commanded the streets – strolling, chatting, setting up shop.

In 1999 colour came into his non-commercial work for the first time. The impetus for this development was an invitation by the Art Gallery of Western Australia to photograph and then to exhibit in their state. He chose to photograph the remnants of a remote village that had been destroyed by blue asbestos mining. Suddenly, colour became the defining quality of the images, and Goldblatt found that the new digital technology gave him the control previously lacking in colour reproduction. He exhibited the work as an over-sized magazine layout. When he returned to Johannesburg, he continued to use colour, believing that it was integral to the banality and excesses of the new Johannesburg. But there is something more than that in these photographs – a newness after the 'Structures' decade, the most sombre of his work; a lightness after the long years of political turmoil.

For the new work emanates a sense of celebration. One series of images, a work in progress, explores the positive new identities that are being forged in post-apartheid South Africa, an emergent class of self-styled craftsmen and builders who are thriving on suburban expansion. Their signs are on every street corner, nailed to trees, tied to traffic lights, etched into rocky outcrops. For Goldblatt, these signs represent industry and initiative – men looking for a market. They also echo his own past – family members who started life as itinerant hawkers, becoming shopkeepers and making good in a middle-class world. The

characters in the new work seem to be saying, 'After the moral wreck of the past, we know where we're going. It's a good place to be. Now we belong.'

'Belonging'. It is a word that has resonated throughout Goldblatt's work since his early recognition of the qualities that reside in the structures and people of his troubled land. Moreover, his photographs speak of his visceral connection to the terrain of his country, its people, and the distinctive intensity of the Highveld light. Even when he is in the underground tunnel of a mine, he knows north from south. It is the place of his belonging.

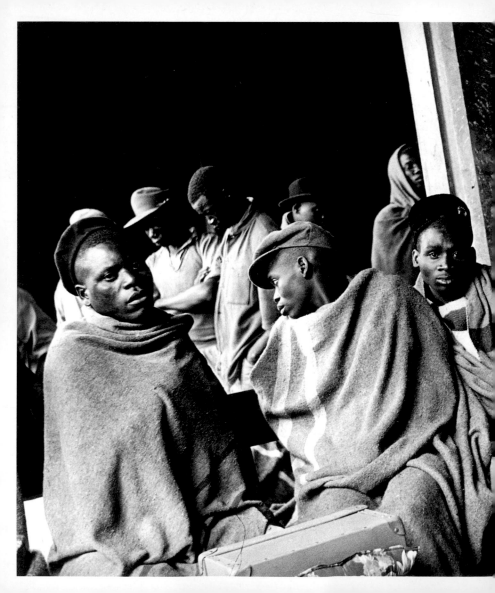

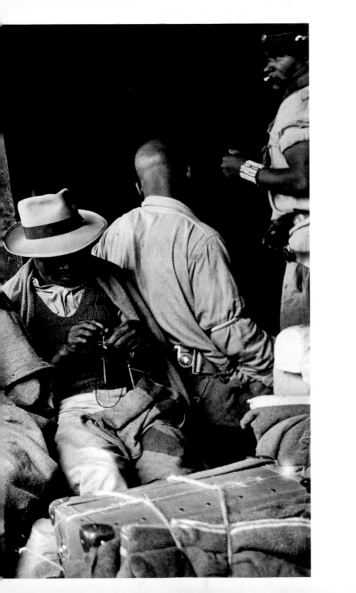

(previous page) Nyassa Miners Going Home After Serving Their Twelve-mont Contract on a Gold Mine, Mayfair Railway Station, Johannesburg, 1952. This is on of Goldblatt's earliest photographs. He recalls: 'It was a gloomy, wet day, ther must have been about a hundred men crowded under the shelter of the wid bridge that crosses the lines there. They spoke quietly among themselves. On played an accordion; another did a sort of shuffling jig. Some knitted. A wind-u gramophone was going at the other end. I must have spent a few hours wit them. The train arrived at about 3.00 p.m. They had been waiting since that tim the previous day … I had hoped that this would be a "picture story" that I coul sell to a magazine. After processing and printing I came to the bitter conclusio that it was not, and stuck the work away. It took some 25 years before I coul look at the photographs without that tinge of disappointment.'

Café-de-Move-On, Braamfontein, Johannesburg, November 1964. Mobil coffee-carts were positioned near railways and factory gates, and their (usuall female) proprietors cooked and sold simple meals for African workers. However they were anathema to Johannesburg council officials, who by 1965 succeede in clearing them from the city streets. This early photograph is an example o Goldblatt's fascination with the tales told by the structures that we build. Mos of the carts, like this one, were built from the cast-off materials of whit Johannesburg – old sheets of corrugated iron, pressed metal ceilings used i late Victorian houses, the wheel borrowed from some ancient barrow.

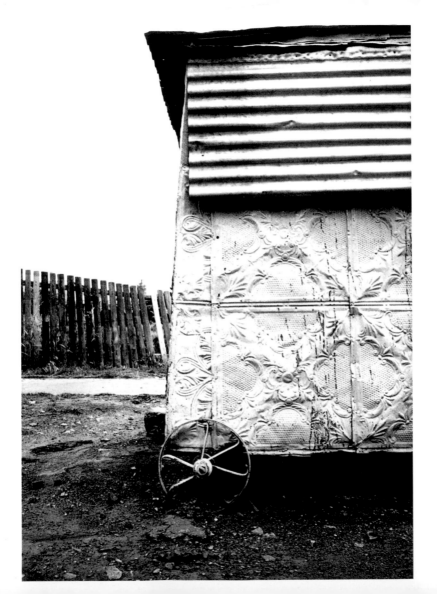

A Railway Shunter by the Dam on his Plot, Koksoord, Randfontein, 1962. These men of the soil called themselves farmers, but most had paid jobs in the towns. This particular man told Goldblatt of his dream to make a garden that would feature neither bricks nor concrete and would be watered by the dam. When this photograph, and the nine that follow, were published in *Some Afrikaners Photographed* in 1975, it caused an immediate outcry. Those who were most offended were wealthy Afrikaners and intellectuals who accused Goldblatt of distortion by showing only the working class. One newspaper editor refused to allow his staff even to look at a review copy, and several bookshops declined to stock it.

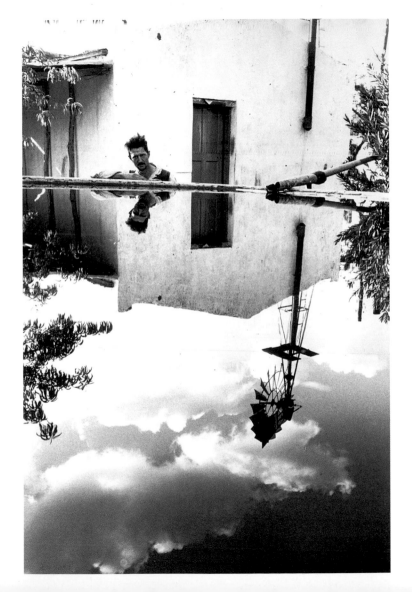

Family at Lunch, Wheatlands Plots, Randfontein, September 1962. The 1960s were industrial boom-time in South Africa. But despite the best efforts of the apartheid government, white poverty was ever a reality. This man had lost a leg in an accident on the railways and was now working in a menial office job. He would cycle four miles to the station every day, to catch a train to work. Of the couple's six children, three had died in childhood. The wife was often incoherent with bitterness and rage.

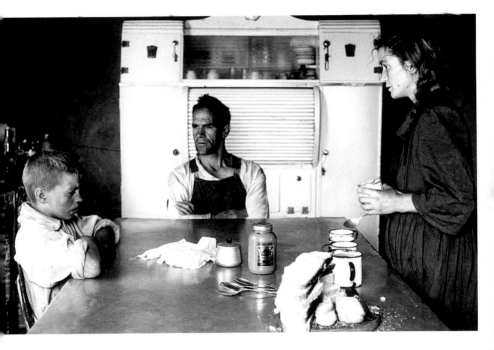

A Plot-holder and the Daughter of a Servant, Wheatlands Plots, Randfontein
September 1962. During his years spent travelling around the smallholdings o
suburban South Africa, Goldblatt became increasingly fascinated by the comple:
relationship between black and white. On the one hand, he despaired at the
racism of these Afrikaners, which seemed to him to be 'in the blood'. Yet at the
same time, there was an intimacy that would have been unthinkable in the libera
homes of the cities. On this plot, the servants' children ran in and out of the
'master's' house. At one point he turned and said, 'Yes, what are you doing here
you black rubbish?' But he said it with affection.

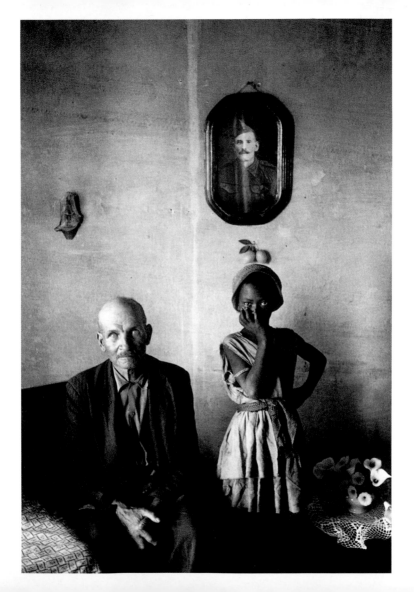

A Farmer's Son with his Nursemaid in the Marico Bushveld, 1964. Both boy and nursemaid are barefoot and lightly clad. The young woman's hand curls about the boy's heel, and his rests lightly on her back. To become a man he must learn that physical intimacy between black and white — however innocent — is prohibited by law. He must learn to despise what he once loved. Between 1950 and 1985, eleven thousand South Africans were convicted under the Immorality Act as it was then known, which prohibited sexual relations between black and white.

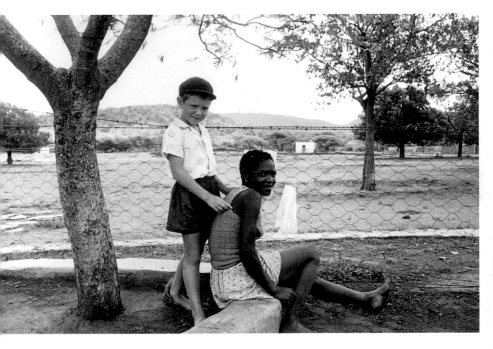

Commando of National Party men escorting their leader, Hendrik Verwoerd, to the party's fiftieth anniversary celebrations, de Wildt, Transvaal, October 1964. This photograph, as with many in the *Afrikaners* book, is printed with the maximum contrast that Goldblatt's sense of documentary realism would allow. He recalls, 'When photographing *Some Afrikaners* I often felt desperately angry. Angry and frightened. I wanted to take it out on something, and I took it out on the film, which I would overexpose and overdevelop. I had to make the negatives as harsh as I could.' The young man at the centre of this photograph, Leon Wessels, was to become a leading member of F.W. de Klerk's reform government in the 1990s. He was the first National Party member to apologize publicly for the wrongs of apartheid.

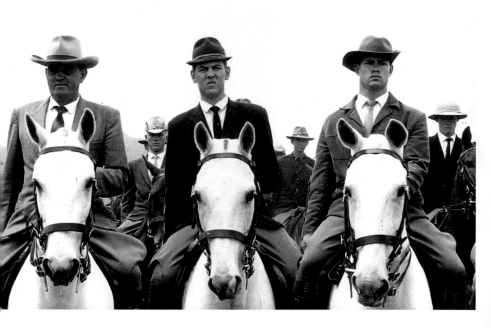

On an Old Transvaal Farm Near Fochville: The Farmer's Wife, 1965. Her husband was not home, but the farmer's wife agreed to be photographed on condition that she could change. She returned in white, perfumed and immaculate, and posed shyly and yet with frank pleasure. She could not have realized that Goldblatt was as interested in the geometry of the light and the play of texture between her frothy skirt and the crumbling facade of the ancient farmhouse as he was in her.

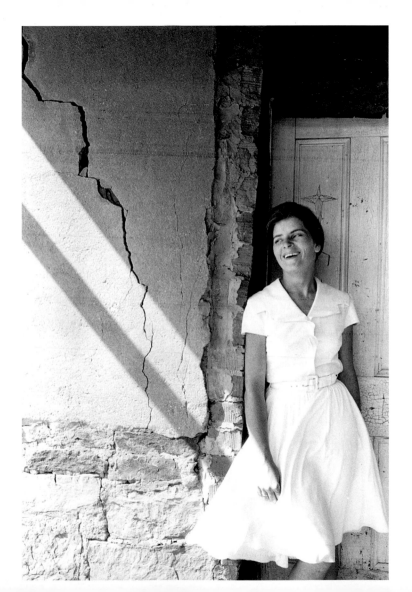

Picnic at Hartebeespoort Dam on New Year's Day, 1965. This, of all Goldblatt's photographs, captures his mounting terror at the Afrikaner plan for South Africa. It seems as if the evil has worked its way into the very dreams of the children – turning brother against brother, boy against babe. Blink again and it's just an innocent game, and a child in abandoned, vulnerable sleep. Either way, there is a thunderstorm brewing.

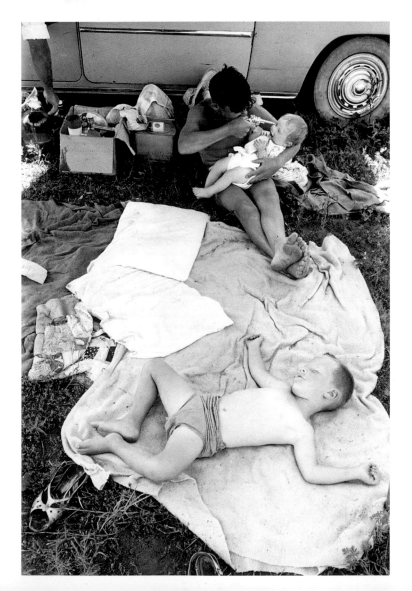

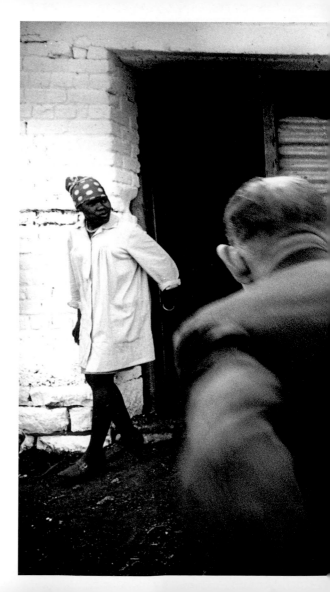

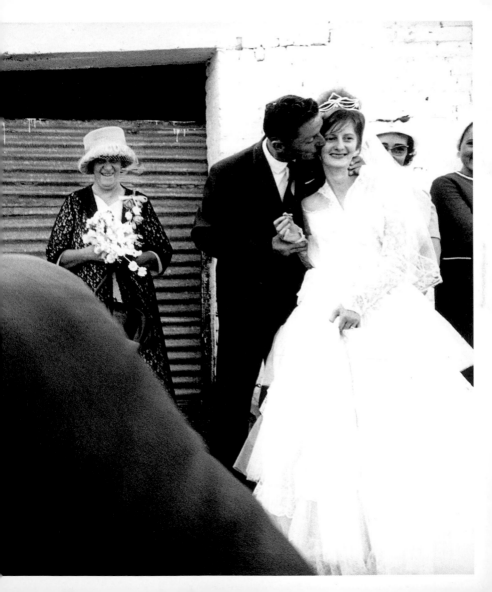

(previous page) **Wedding on a Farm near Barkly East, December 1966.** The wedding was held in a dairy that had been swept and decorated with crepe paper for the occasion. The bride was beautiful and innocent; the groom proprietorial. The groom's father railed against 'Kaffirs', Jews and 'Commies' and was unable to hide his contempt for the photographer. The unstructured framing of this photograph is unusual for Goldblatt, particularly in this period. It speaks of the wildness of the drink and dance, the unpredictability of the event.

The Marais' Daughter, Die Hel, Cape, December 1967. The road to the valley of Die Hel ('the hell' in Afrikaans) was built five years before this photograph was taken. Prior to this, the community's only connection with the outside world had been by means of an annual caravan of donkeys that drove over the mountains to the nearest town. Goldblatt found the people quite untouched by the political and material concerns of the time. For example, his host was puzzled by Goldblatt's offer of cans of beer, asking him to explain what they were. When Goldblatt returned in 1990, only one family remained.

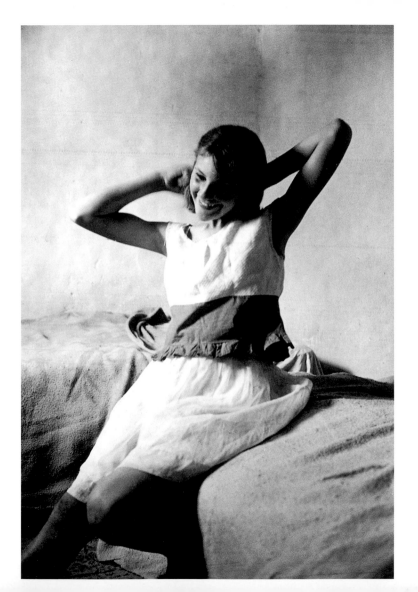

'Boss Boy', Battery Reef, Randfontein Estates Gold Mine, 1966. In the mid-1960s, between two and three hundred thousand black miners worked the mines of South Africa's great gold reefs every year. They were confined by law to the least skilled types of work, though within the work teams a strict hierarchy prevailed, rewarded by differences in pay and prestige. The team leader, the 'Boss Boy', displayed his rank with pride on his left arm. In his left-hand pocket is a clinometer for underground measurements, a notebook for recording them, pens and a pipe. On his wrists are a plastic identity band, and ornamental copper and rubber bands. On his belt is a pocket-knife in a home-made sheath and Zobo watch presented by the company for recognition of accident-free work.

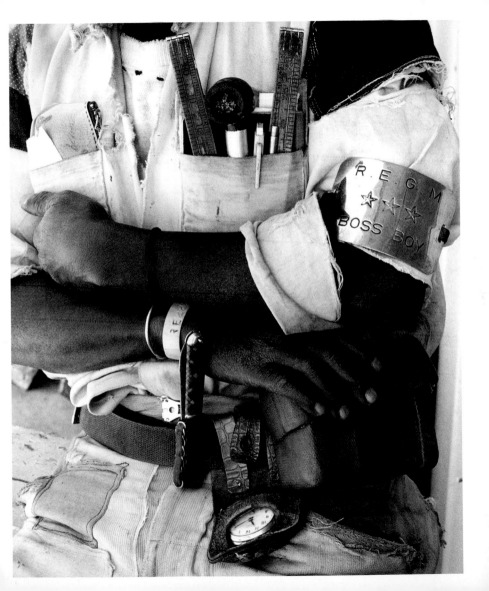

Air and Water Hoses Being Connected for Drilling the Blast Holes, No. 4 Shaft President Steyn Gold Mine, Welkom, 1969. South Africa's gold reefs dip thousands of metres below the earth's crust. This photograph of the comple and dangerous process of shaft-sinking was taken at a depth of about 2,000 metres. Goldblatt worked under the light of two halogen lamps that hung abou 25 metres above the bottom. At times, there was a 'cathedral-like' soft clarity t the light. At others, a dense fog of driven grit and water cut visibility down to couple of metres. Goldblatt developed a technique of loading the camera unde his oilskins, and never lost a film. But by the last shift of the last day, ever function on both Leicas was jammed. The cameras and all the lenses had to be stripped and rebuilt. He is still using them.

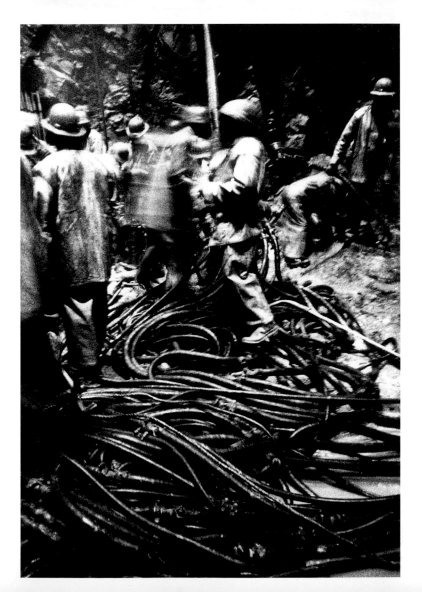

Lashing or Loading a Kibble, No. 4 Shaft, President Steyn Gold Mine, Welkom **1969.** Nadine Gordimer, who worked with Goldblatt on *On the Mines*, described this photograph as 'a vision of hellish beauty from a level of the underworld Dante's imagination never reached'. However, she says, Goldblatt does not let us forget that 'those shrouded figures, buried, moving through mists of dust and water, are not Shades; they are real men'.

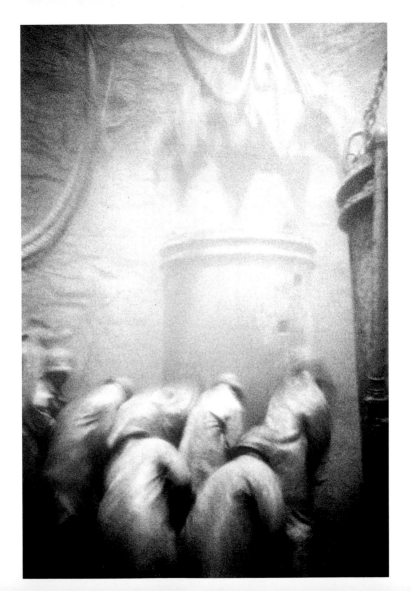

Butch Britz, Master Shaft-Sinker, No. 4 Shaft, President Steyn Gold Mine, Welkom, 1969. The Master Sinker is responsible for every aspect of the vastly expensive shaft-sinking operation. He must maintain a balance between critical mining needs, safety and speed. Master Sinkers are rarely easy men; they tend to live on their nerves and some are heavy drinkers.

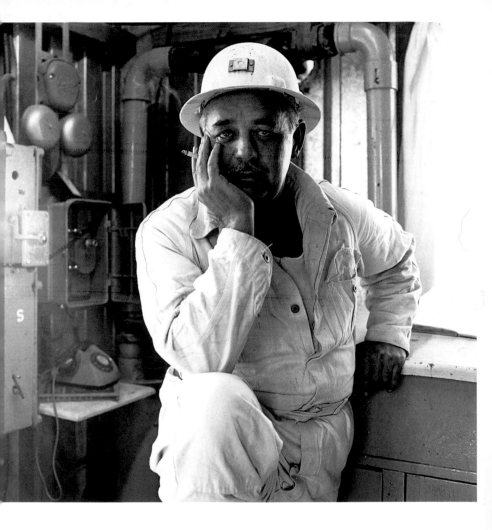

Sunday Afternoon: Margaret Mcingana at Home, Zola, Soweto, Johannesburg, October 1970. For Goldblatt, this photograph is symbolic of many aspects of Soweto life and is one of the few that hangs in his own home. It encapsulates what he sees as the astonishing ability of Sowetans to achieve a sense of ease and normality in the harshest of environments. Mcingana, who later became well known as the singer Margaret Singana, relaxes in obvious enjoyment of her own sensuality, while above her looms a wall that seems to bear the scars of violent assault.

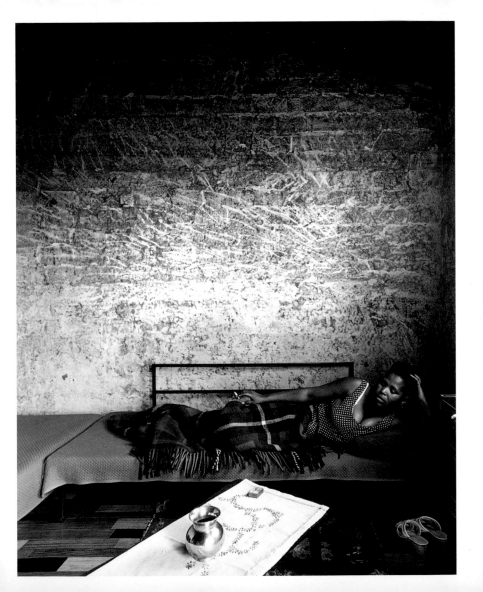

At the Cup Final, Orlando Stadium, Soweto, Johannesburg, November 1972
Drum majorettes play a big part in the public life of the township. At a youn
age, girls learn to balance their charms against the weight of maleness, whic
looms heavily in the background of their lives.

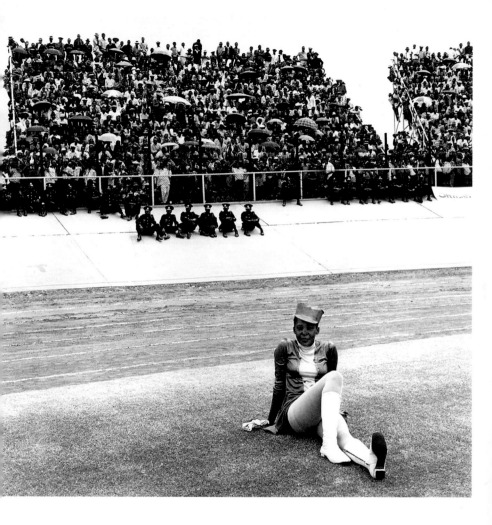

Sunset Over the Playing Fields of Tladi, Soweto, Johannesburg, August 1972
Soweto chokes in the winter months. The smoke from thousands of coal fires i
trapped in a low sky by temperature inversion. Babies and old people die o
respiratory illnesses. Motorists who have lived in the township all their live
lose their way in the smog. Here, children play barefoot on the twisted metal o
car wrecks while the sun goes out.

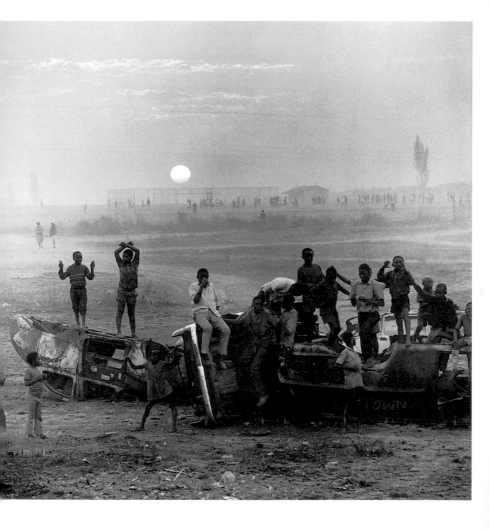

The Coal Merchant's Horse, Tladi, Soweto, Johannesburg, November 1972. Th horse was condemned and shot by an inspector because of an injury to it mouth. It was immediately butchered and sold to neighbouring housewives wh queued, behind the camera, with buckets to buy the meat.

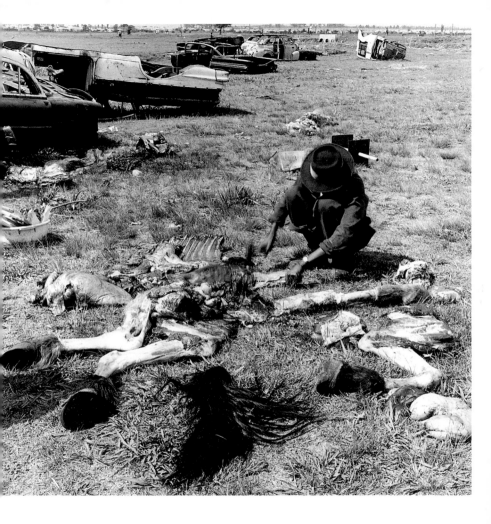

Ephraim Zulu Watering his Garden, Central Western Jabavu, Soweto, Johannesburg, September 1972. Many township residents water the bare patches outside their houses to keep the dust levels down. This becomes essential at the end of a dry winter.

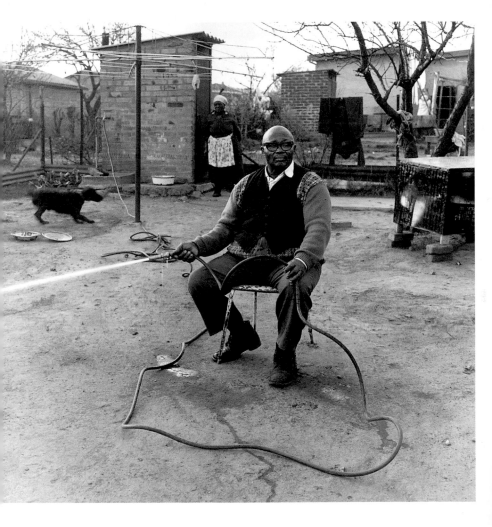

A Baby in its Crib in a Rooming House, Hillbrow, Johannesburg, March 1973
At this time, Hillbrow was the heart of South Africa's counterculture, with its fol
singers, smoky cafés, record bars and all-night clubs. It was also a place for nev
arrivals to the city: transients and hopefuls, foreign immigrants and young peopl
fleeing the poverty and boredom of the countryside. Goldblatt photographed man
occupants of this rooming house, where a cardboard suitcase proudly passes as
baby's crib.

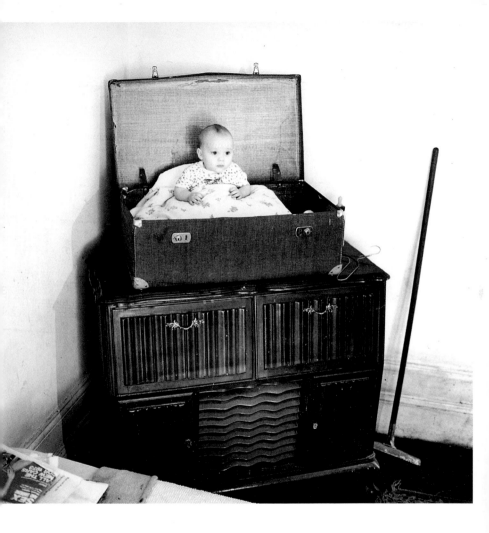

Forest and Houses near Coffee Bay, Transkei, 1975. Many of Goldblatt's photographs taken in the townships or in black rural areas rejoice in voluptuous tones, almost as if in compensation for the degraded lives of their subjects. Goldblatt comments: 'For someone accustomed to photographing the light and the landscape of the Highveld, the Transkei landscape was very rich. But perhaps because of that I found it too easy.'

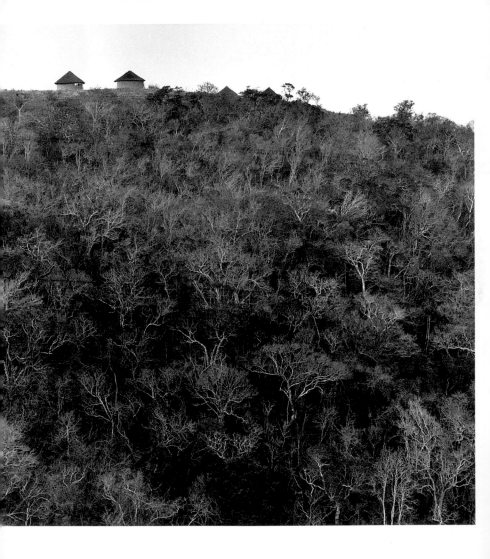

A Circumcision Initiate in the Hut of the Initiates, Pondoland, Transkei, 1975
Goldblatt received formal permission from the head of the male circumcision school to photograph the initiates in their huts. This kind of photograph can be controversial in South Africa. Another photographer's work on the secret circumcision rites was stolen from the gallery in which it was hanging by people who wished to prevent the uninitiated, especially women, from seeing it.

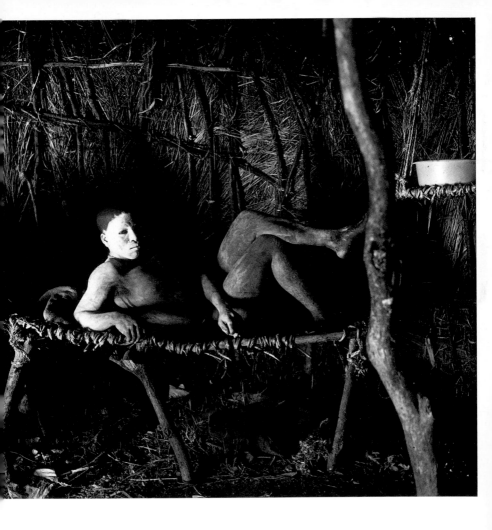

A Peasant Woman at Home, Coffee Bay, Transkei, 1975. In Xhosa culture it is customary to give a gift to a visitor. This woman was reluctant to allow Goldblatt into her house because she was too poor to give him anything. She and her children spent most of their days digging for roots in the bush. This was their only food.

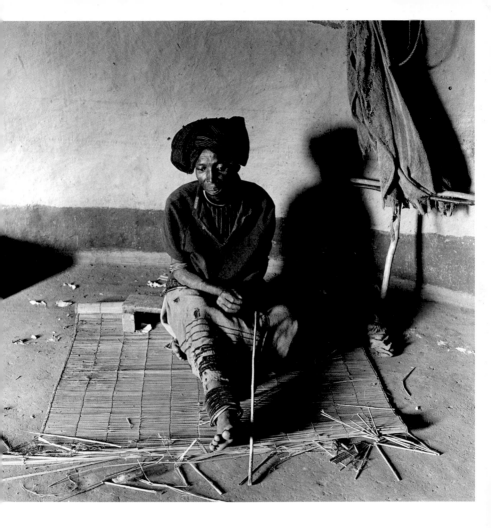

Grandmother and Child, Transkei, 1975. Goldblatt began work on the photo
graphs he called *Particulars* before he went to Transkei. 'I felt I had to try to pu
down on film my almost uncomfortably acute awareness of people's bodies an
of their minute details,' he commented, 'the beauty, often in the most unlikel
places, and the sensuality, and the sex too; my awareness of the marks of expe
rience and time as evidence of life lived and of life running on and out.'

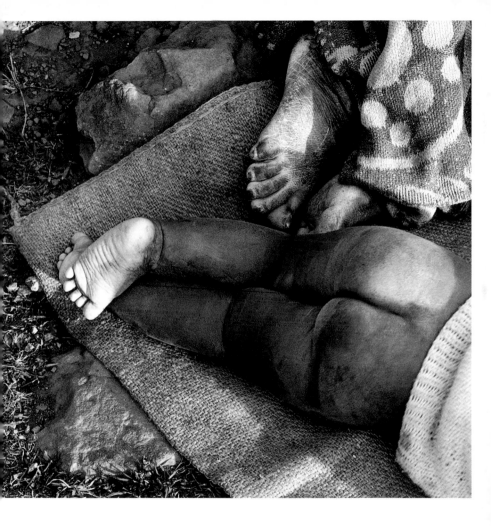

Man at a Trading Store, Bomvanaland, Transkei, April 1975. This photograp
gives a vivid example of how the detail may interrogate the whole. A doctor wh
saw it said that the man was almost certainly suffering from TB. The elongatio
of the fingers was the telltale sign.

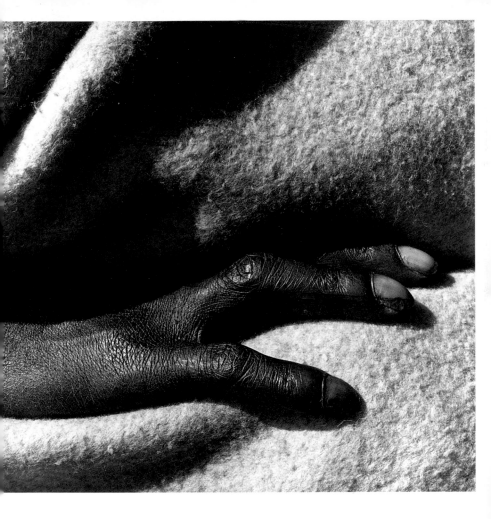

Woman on a Bench, Joubert Park, Johannesburg, April 1975. The *Particular*. photographs speak volumes, not only of the subjects (the small touches of vanity that betray them), but also of place and time. In the 1970s, Joubert Park, in the centre of Johannesburg, was the favoured resting place of travellers, all-night revellers, workers and inner-city residents of all types. White shoppers in their best clothes rested their weary thighs on park benches. For many black visitors, the park was home. But, prohibited from using the benches, they would sit and lie on the grass. Today, black people have claimed the benches, and whites, fearing crime, have fled.

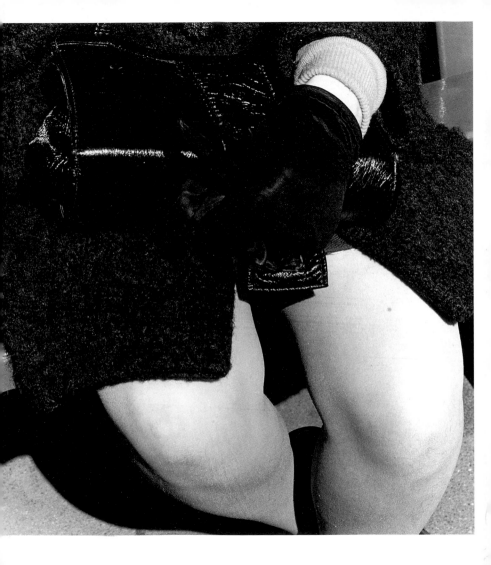

Man Resting, Joubert Park, Johannesburg, 1975. In *Particulars*, Goldblat revelled in the cutting quality of the Highveld light, which enabled him to revea every pore of his subjects. This enjoyment is carried through into the darkroom He says, 'There is nothing to beat the excitement of a black and white prin coming out of the fixer. I seem to have an almost visceral relationship with blac and white negatives.'

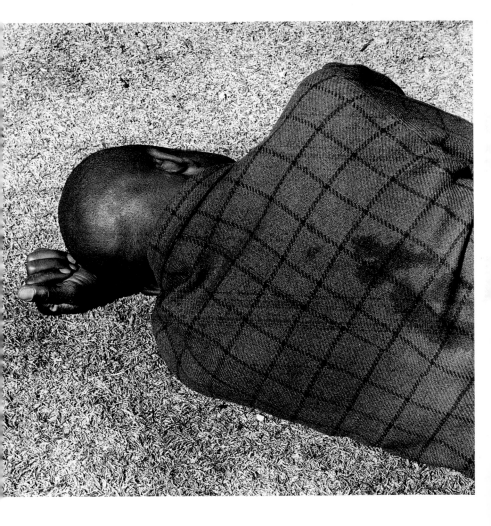

The Docrats' Bedroom Before its Destruction Under the Group Areas Act, Pageview, Johannesburg, 1976. The Docrats' bedroom, with its textured shell pattern on the walls and twin beds (made to order — an almost unaffordable luxury), speaks of 25 years of marriage in the same house. It is a polite room – painfully neat, the two beds identical except that only one reading lamp has a cord (is it Mr or Mrs who reads late into the night?). Until now, their life together has been an ordered one, with few surprises. We do not see the bulldozers, but the stillness of this room enables us to hear them drawing near, and to anticipate the awful consequence. After the family was relocated to the township of Lenasia, 40 kilometres away, Mr Docrat cut six inches off each bed so that they would fit into the new room.

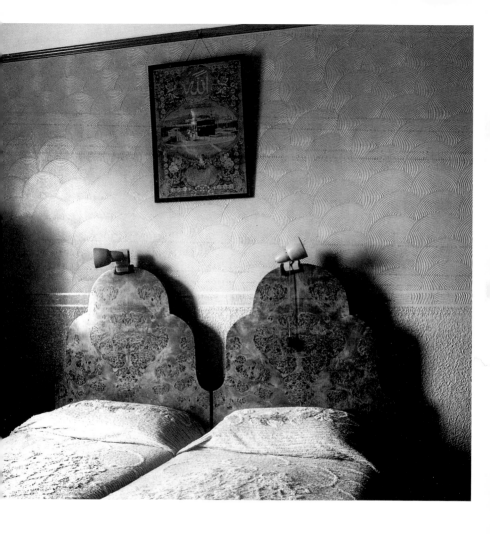

Schoolboy with Scrolls of Merit, Boksburg, 1979. This and the six photograph that follow were published in the book *In Boksburg* in 1982. It was a portrait of small-town white life in the time of 'Total Onslaught' – the term the governmen used for the war against enemies of apartheid. Goldblatt saw this boy as a whit leader of the future, the kind of young man sought out for leadership in th police and army who would take the system to new heights.

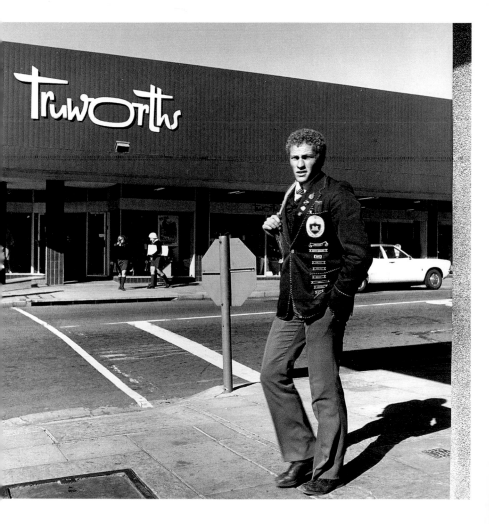

'Spec' Housing and Children on the Veld at Parkrand, Boksburg, 1979. This i
one of few amongst his photographs that Goldblatt would describe as lyrica
Though it is located in a depressing housing development, it speaks of th
freedom of a small-town South African childhood.

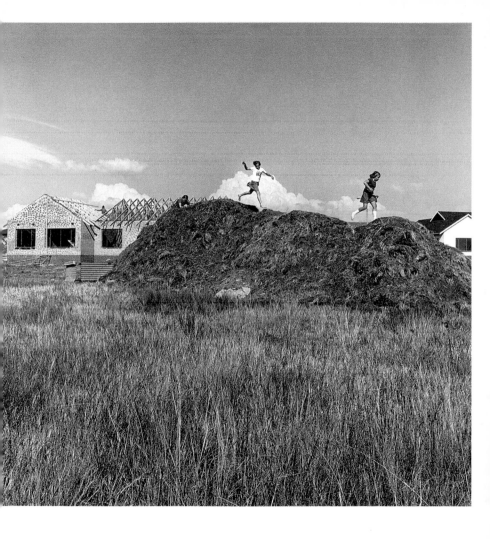

Dancing-master Ted van Rensburg watches two of his pupils swinging to the music of Victor Sylvester and his Orchestra, in the MOTHS' Hall at the Old Court House, Boksburg, May 1980. The *Boksburg* work records the world in which Goldblatt grew up — small-town, white, middle-class South Africa. He recalls: 'While I brought affection to it, I was concerned to probe and lay bare its values and my relationship to them. There is much in these photographs that is, in a sense, autobiographical.'

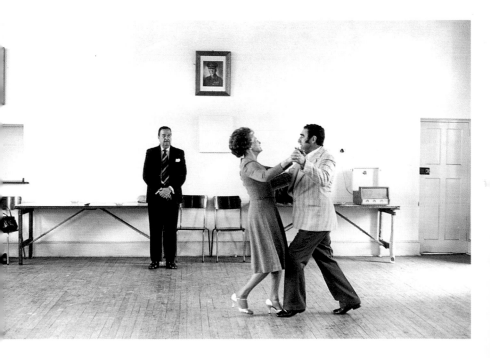

Girl in her New Tutu on the Stoep, Boksburg, 21 June 1980. This photograp captures Goldblatt's complex feelings of anger and compassion towards hi white subjects. Goldblatt celebrates the girl's budding beauty, but on the sun drenched stoep, under the shadow of the trellis, she is already trapped in value that she is probably condemned to live out for the rest of her life.

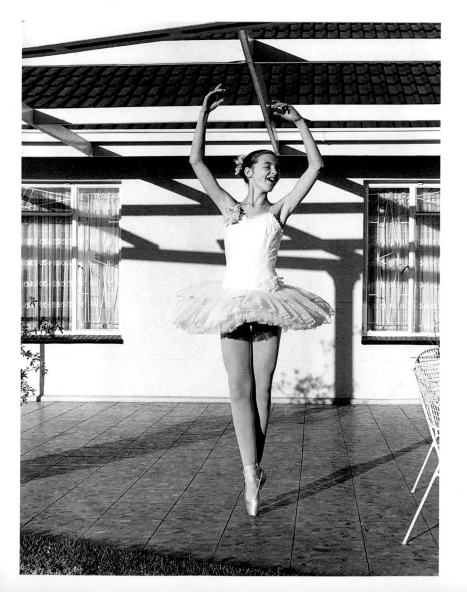

Saturday Morning at the Hypermarket: Miss Lovely Legs Competition, Boksburg, 1980. Goldblatt made notes of his feelings in relation to this event: 'Raw nubility, white only, paraded on the block, free for all to see. In the levelling of the market both the exposure and the looking sanctioned. Withal, a kind of innocence, the girls awkwardly daring rather than knowing, the audience seemingly amused and amazed rather than leering. Tacit acceptance all round that only Whites could compete. At home such intimate exchanges of display and gaze between, say, the daughter of the house and the Black gardener would have been unthinkable. Not least because in 1980 the Immorality Act, prohibiting sexual intercourse between South Africans of different races, was still in force. My seeing, sanctioned by the camera, neither innocent nor unknowing.'

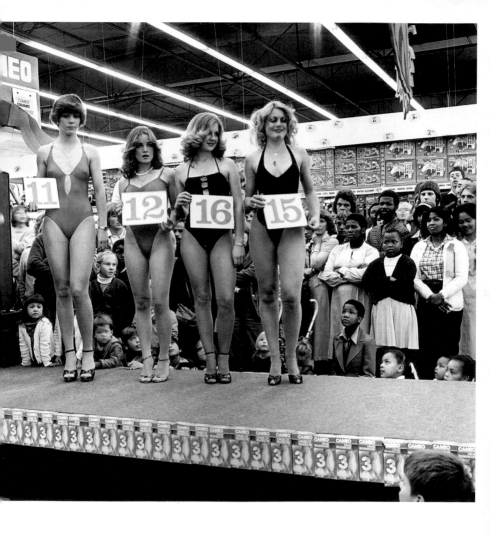

East Rand Methodists meet to find ways of reducing the racial, cultural and class barriers which divide them, Daveyton, Benoni, 3 July 1980. In the early 1980s, a sliver of white South Africans, led by the churches, began to examine their role in the society. This was the only manifestation of this phenomenon that Goldblatt came across in Boksburg.

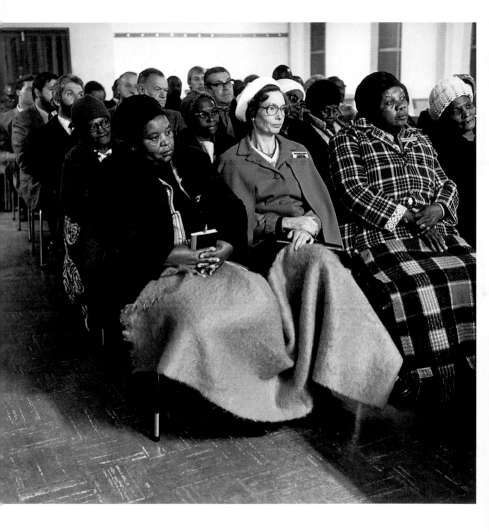

Funeral with military honours for two White conscripts, boyhood friends, killed in the same action against SWAPO forces on the Namibia–Angola border, Boksburg, 18 June 1980. The young soldier in the ill-fitting trousers was part of a unit that travelled around the country to give military funerals to the large numbers of young whites who had died on the border. There were many casualties and it was cost-effective to have a dedicated unit with special training and equipment to conduct the funerals.

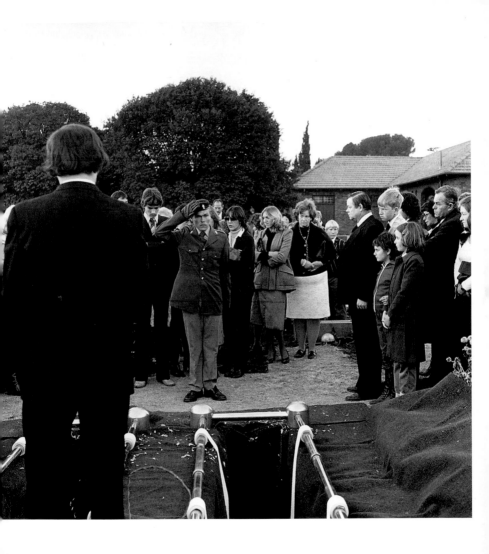

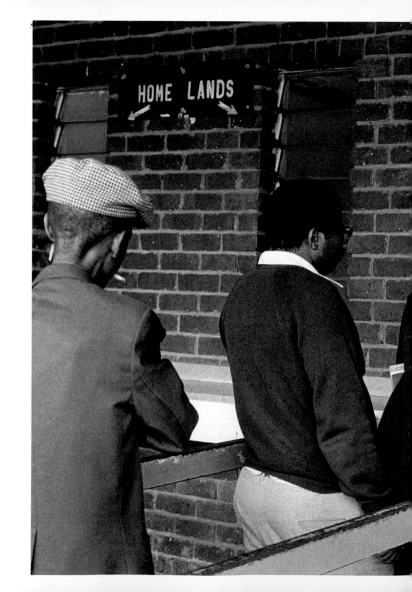

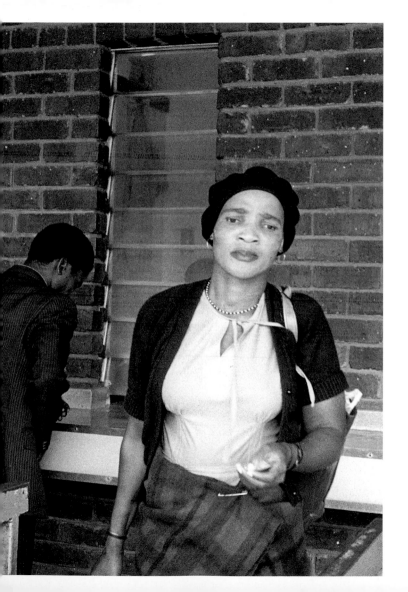

(previous page) **Travellers from KwaNdebele Buying their Weekly Season Tickets at the Bus Depot in Pretoria, 3 January 1984.** KwaNdebele was a 'homeland' to the north of Pretoria to which large numbers of black South Africans had been forcibly removed. There was little employment in this nominally independent state, and as its 'citizens' had no legal rights to live in the white areas of South Africa, they commuted daily from KwaNdebele to Pretoria where they worked, and back again. Many travelled for up to eight hours a day.

Going Home on the Bus from Pretoria to KwaNdebele, 3 January 1984. The time is about 8.45 p.m., and there are still forty-five minutes to go before the bus reaches the terminus in KwaNdebele. For most of the people, the cycle of travel and work will start again the next day at between 2 and 3 a.m.

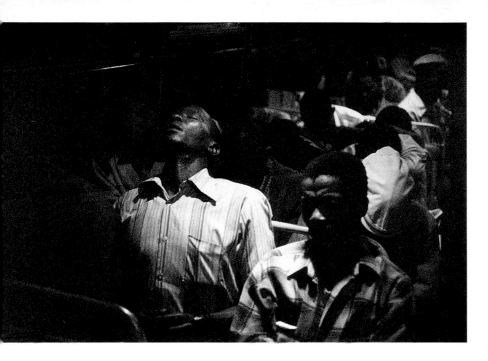

Fifteen-year-old Lawrence Matjee After his Assault and Detention by the Security Police, Khotso House, de Villiers Street, Johannesburg, 25 October 1985. After a stone-throwing incident at his school, the police arrived at Lawrence Matjee's house in the middle of the night. Giving him no time to put on his trousers, dragging him into the street by his feet, they kicked his hands so hard that they were pushed back into his wrists. He was then held in detention for six days without medical help. His friends, who were arrested along with him, pulled his hands from his broken wrists.

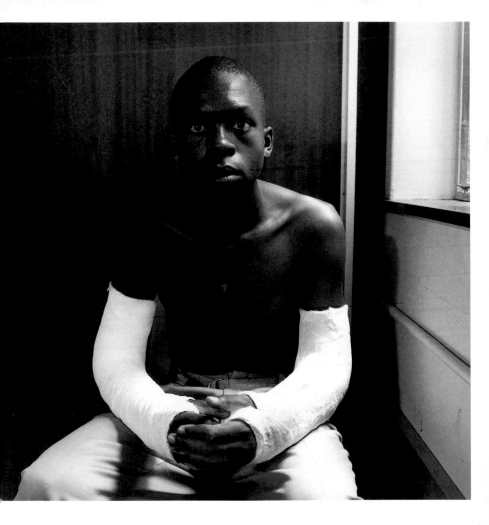

Mother and Child, Crossroads, Cape Town, 11 October 1984. This image and th
following eight come from the series 'South Africa: The Structure of Thing
Then.' Crossroads was an illegal black settlement outside Cape Town. Th
authorities engaged in many battles over the years to remove its residents t
the so-called homelands from which most had come. Goldblatt had watche
while officials of the Western Cape Development Board destroyed the brush
wood framework of this shelter. Afterwards, for a while, the woman lay with th
child, then she got up and began to cut branches from the nearby scrub to mak
a new roof.

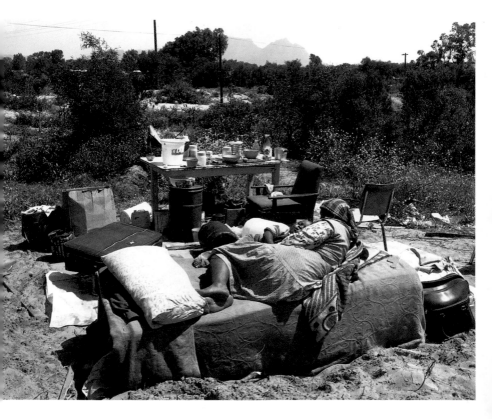

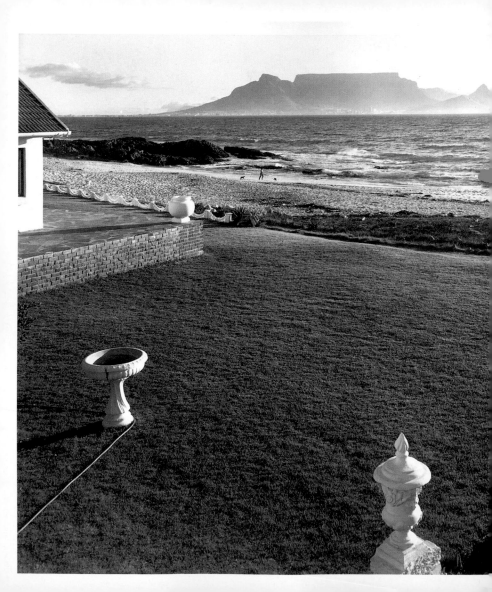

(previous page) Suburban Garden and Table Mountain, Bloubergstrand, Cap Town, 9 January 1986. In 1986 this beach was part of a 13-kilometre stretc reserved for whites (and their dogs).

The Heroes' Acre, Ventersdorp, Transvaal, 1 November 1986. This cemetery wa built for white members of the security forces killed in the Total Onslaught Only two national servicemen are buried here. One was killed in the black town ships and the other in a military operation in Namibia. The inscription abov the gate is from the Afrikaner national anthem and translates as 'We for you South Africa'.

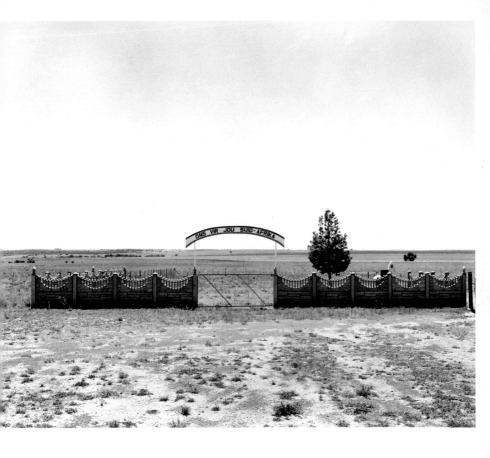

Dutch Reformed Church, Quellerina, Johannesburg, November 1986. In the course of photographing South African structures, Goldblatt arrived at the notion that shifts in the architectural style of Dutch Reformed churches were closely related to changes in the political beliefs and fortunes of the Afrikaner people. He believes that the Quellerina church, which was completed in 1984 exemplifies churches built in the period when the apartheid dream began to fail In this phase, the church became a blind thing – a fortress. Without windows the word of God no longer went out into the world, but was reserved for the converted, the Elect.

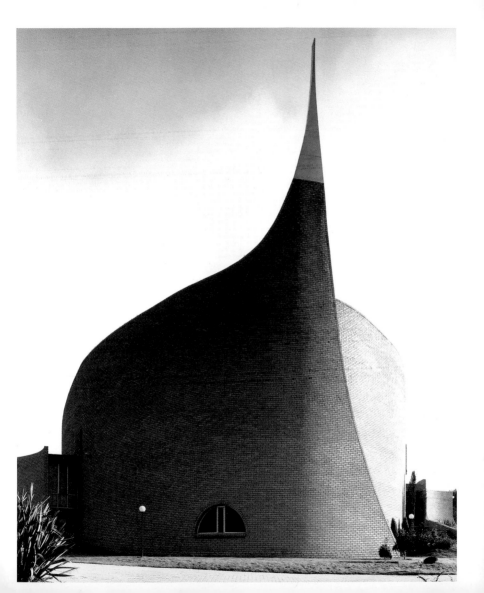

Hostel for African Men, Alexandra Township, Johannesburg, June 1988. When this hostel was opened in 1972, the intention was that Alexandra should become a dormitory township of 'single' African men and women, housed in vast hostels, providing labour for Johannesburg. All family housing there was to be abolished and their occupants removed. This was a blow for those who had lived in Alex since its inception and had title deeds to their properties. Though many residents were expropriated and removed, the grand plan for Alex was eventually scrapped. The hostels remained and became sites of bloody conflict in the township wars of the 1990s.

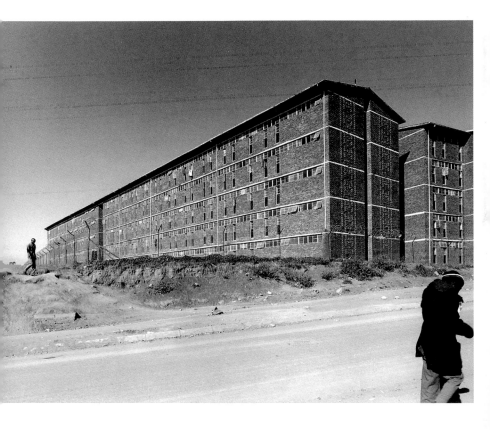

Sculpture, Maximum Security Prison, Robben Island, 16 July 1991. This sculpture was made to commemorate the prisoners on Robben Island. The figure represents the first political prisoner on the island, the Khoikhoi chief Autshumato, who was marooned there by the Dutch in 1658. The contemporary style and fabric of the underpants symbolically represent the modern prisoners like Mandela, who were incarcerated there. The sculptor, Japhta Masemola, a long-term political prisoner, died in a motor accident shortly after his release from prison in 1989. After political prisoners were freed, common-law prisioners attempted to use the steel armatures as weapons and the authorities destroyed the sculptures in 1992.

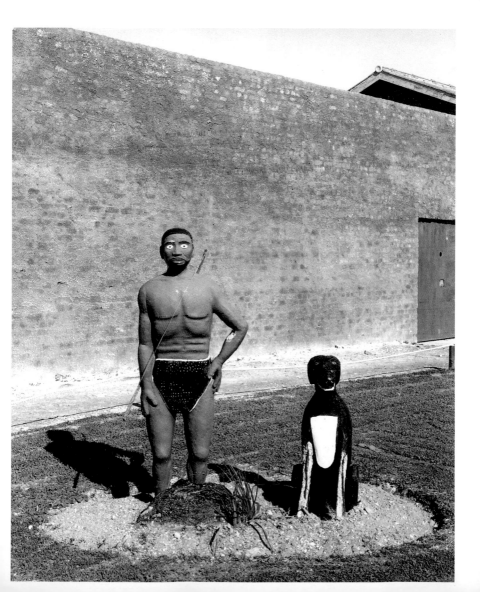

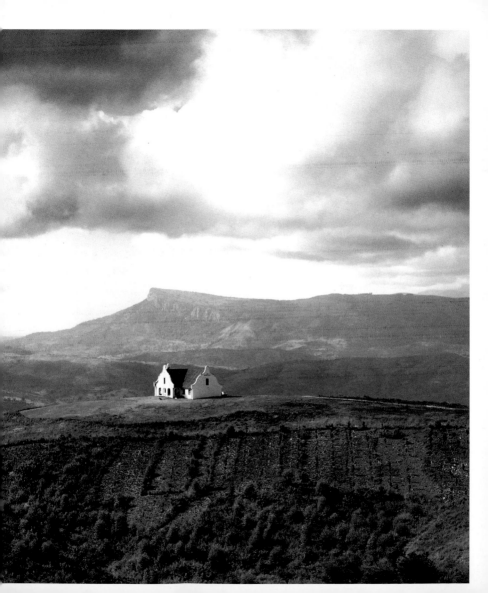

(previous page) House in Pseudo Cape Dutch Style, Agatha, Tzaneen, 10 Apri **1989.** The historian C.W. de Kiewiet wrote, 'On the great farms each man fled the tyranny of his neighbour's smoke.' Goldblatt writes: 'Only this was not a farmhouse. This was "spec" housing in "authentic Cape Dutch style" by a property developer on a rural view site.'

In Mildred Nene's Beehive Dwelling, KwaCeza, KwaZulu, 31 July 1989. Mildred Nene lived in this house with two unmarried daughters and six grandchildren. I took the three women two months to build it from wood and grass that the collected from miles around and brought on their heads to the homestead.

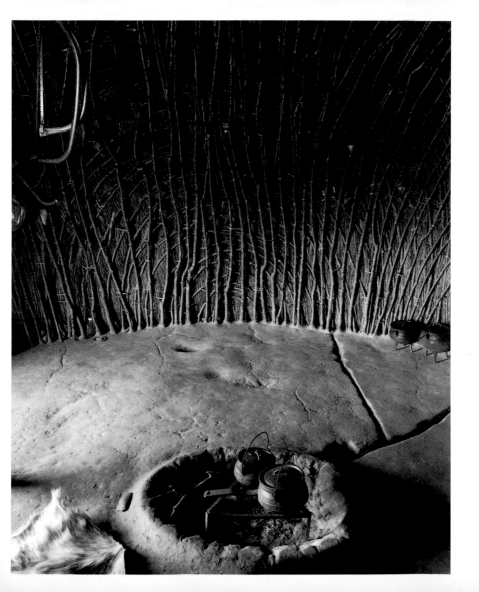

A Man Building His House on His Own Plot of Ground, Marselle Township, **Kenton-on-Sea, Cape, 8 July 1990.** This is the final photograph in the *Structures* book. 'It was a climactic moment and photograph,' said Goldblatt. 'In all the shittiness of matchbox houses and the tall masts of high-security lighting, here was a man building his own house on a piece of ground to which he had legal title. This could not have happened in black townships since 1913, when Africans were denied urban property rights and hence the ability to raise mortgages and build their own homes. There was something in his body language – something about the way he thrust his body – which spoke of strength and good hope.'

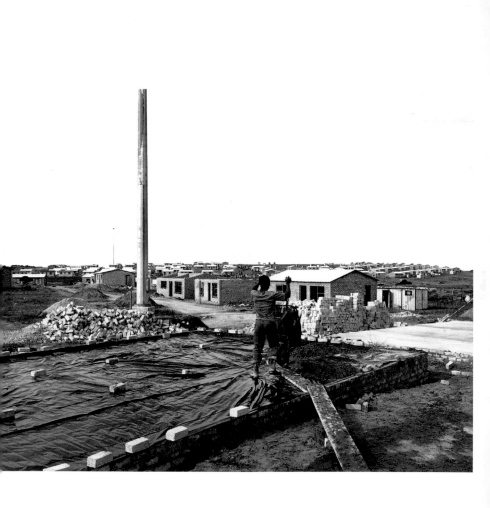

A Barber on Smit Street, Hillbrow, Johannesburg, 19 May 1999. This photograph is one of a series that Goldblatt began in the inner city, after the apartheid laws were gone. It speaks eloquently of the streets of the new Johannesburg. Where once black people feared to linger, they are now in command of their own destinies.

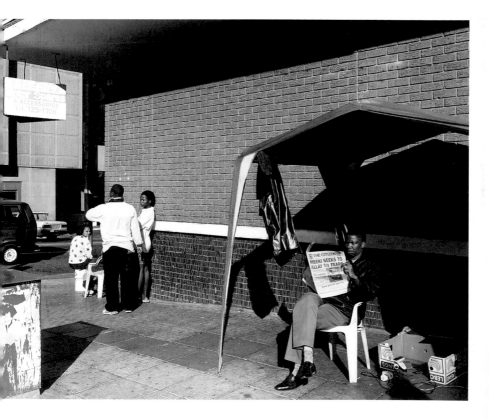

Onward to Caesars! William Nicol Drive, Johannesburg, 3 July 1999. For muc
of his new work, Goldblatt uses a handmade 4 x 5 field camera, the Panfiel
After wearing out (and being worn out by the imprecision of) three Sinar fie
cameras, Goldblatt, together with a few colleagues, urged Andrew Meintjes,
gifted craftsman and inventor, to build a camera that would be precise, toug
lightweight and stripped of all gadgetry, and that would have just those move
ments most needed outside the studio. The Panfield now has a growing place
the world market.

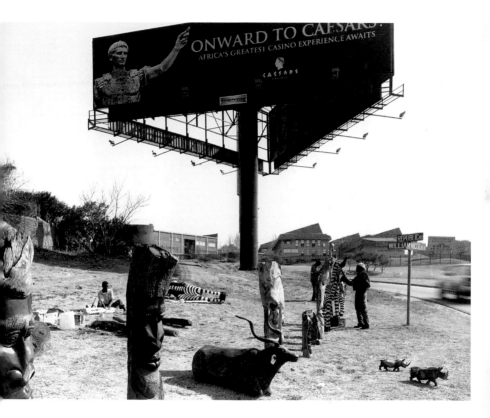

Advertisement, Fourways, Johannesburg, 27 November 1999. These roadsid advertisements are to be found on many streets of Johannesburg's elit suburbs. As improbable as it may seem, this emergent class of painters an builders is able to command attention with its unconvincing hand-painted signs

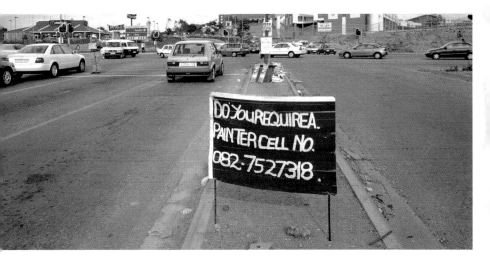

Corrie Jacobs, Painter, at Work in Rivonia, Johannesburg, 12 April 2000. Afte[r] photographing the signs, Goldblatt contacts the advertisers and photograph[s] them in the newly built or renovated suburban homes in which they work. Man[y] of these tradesmen are from the former rural homelands and are making ne[w] lives for themselves in post-apartheid South Africa.

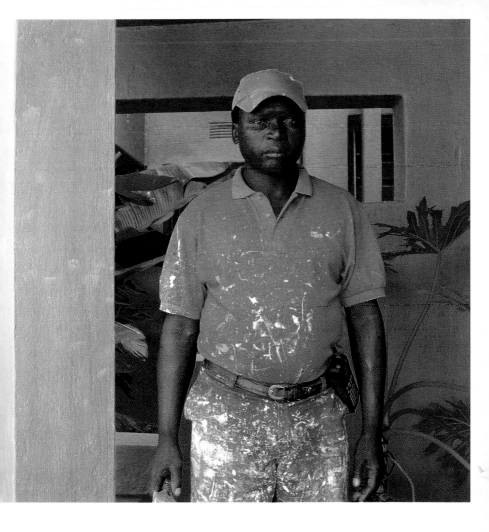

Tymon's Sign, Oaklands, Johannesburg, 20 November 1999. Goldblatt found i
fitting that the delicacy of this sign was so perfectly complemented by one of th
city's rare moments of great beauty – the flowering of the jacaranda trees.

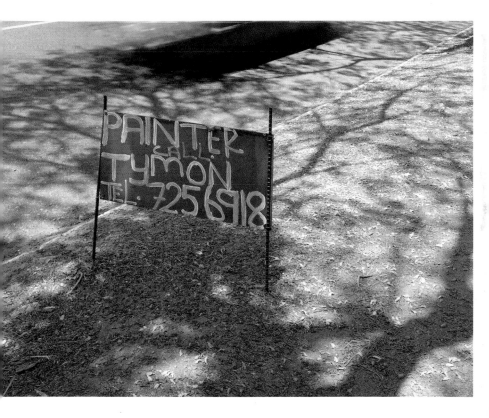

Erickson the Tiler at Work, Linden, Johannesburg, 1 January 2000. Public holidays or not, and 1 January is one of the most important, these independent tradesmen have to work hard for their living.

-

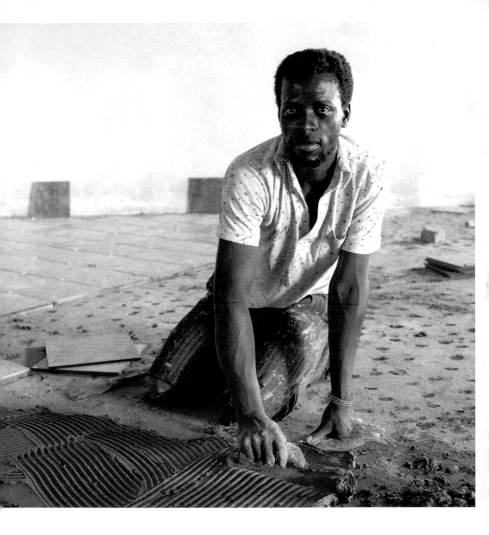

Xolani Shezi, Flower Seller, Senderwood, Johannesburg, 1 April 2000. Trader
and craftsmen are the subject of a new body of work in which Goldblatt i
using colour for the first time in his personal oeuvre. 'Developments in colou
negative emulsions and digital reproduction technology have made colour a
much more flexible and therefore interesting medium for me. Some of the nev
emulsions have a less saccharine palette, combined with greater latitude, tha
earlier films. The digital process yields prints of considerable subtlety with
when desired — a desaturated colour, which accords with my sense of the
Highveld and its light … I am often surprised at how the world looks in colour.'

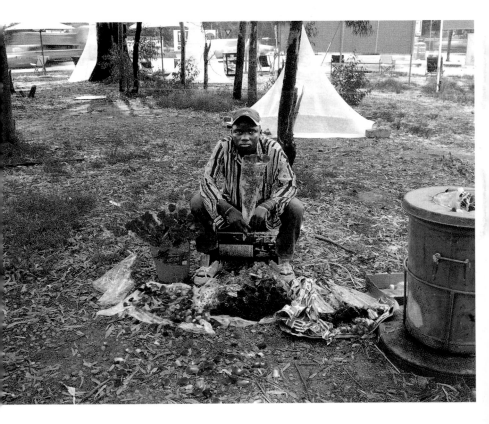

1930 Born in Randfontein, South Africa, the grandson of Lithuanian Jewish immigrants who came to South Africa to escape persecution.

1948 Leaves Krugersdorp High School, where his interest in photography began. Unable to pursue his desired career of magazine photographer, he works in the family men's outfitters business in Randfontein. Simultaneously studies for a Bachelor of Commerce degree at Witwatersrand University, and continues to develop his interest in photography.

1955 Marries Lily Psek.

1957 Son, Steven, is born.

1960 Daughter, Brenda, is born.

1961 Begins his life work, a series of critical explorations of South African society.

1963 Following his father's death, he sells the family business and devotes himself entirely to photography. Work is published in British *Town Magazine*, which encourages his entry into professional photography. Undertakes a variety of assignments for magazines, corporations and institutions in South Africa and overseas. Second son, Eli Ron, is born.

1973 Publishes *On the Mines*, with text by Nadine Gordimer.

1975 Publishes *Some Afrikaners Photographed*. Controversial reception of the work with some booksellers refusing to stock the book.

1976 First major exhibition outside South Africa held at the Photographers Gallery, London.

1977 Museum of Modern Art, New York, acquires a body of his work.

1981 With photographer Margaret Courtney-Clarke and writer John Kench publishes *Cape Dutch Homesteads*.

1982 Publishes *In Boksburg*.

1983 Begins project photographing South African structures.

1985 Documentary *David Goldblatt: In Black and White* is shown in the UK, US and Australia.

1986 Publishes *Lifetimes: Under Apartheid* in collaboration with Nadine Gordimer. Major exhibition at Photographers' Gallery, London.

1987 Hallmark Fellow at the Aspen Conference in Design, Aspen, Colorado.

1989 Publishes *The Transported of KwaNdebele* with texts by Phillip van Niekerk and Brenda Goldblatt. Founds the Market Photography Workshop, Johannesburg, to enable visual literacy and photographic skills among young people disadvantaged by apartheid.

1992 Awarded Gahan Fellow in Photography, Harvard University.

1993 Begins researching and writing text on South African structures.

1995 Awarded Camera Austria Prize for an excerpt from his essay 'South Africa: The Structure of Things Then'.

1998 Publishes *South Africa: The Structure of Things Then*. Exhibitions based on this work at the Museum of Modern Art, New York, the Netherlands Architectural Institute, Rotterdam, the House of Culture, Berlin, and the South African National Gallery, Cape Town.

1999 Invited by the Art Gallery of Western Australia to photograph in that state. Produces a photographic essay on Wittenoom, a village affected by the mining of blue asbestos.

2001 Major retrospective exhibitions in Barcelona and New York.

Photography is the visual medium of the modern world. As a means of recording, and as an art form in its own right, it pervades our lives and shapes our perceptions.

55 is a new series of beautifully produced, pocket-sized books that acknowledge and celebrate all styles and all aspects of photography.

Just as Penguin books found a new market for fiction in the 1930s, so, at the start of a new century, Phaidon **55**s, accessible to everyone, will reach a new, visually aware contemporary audience. Each volume of 128 pages focuses on the life's work of an individual master and contains an informative introduction and 55 key works accompanied by extended captions.

As part of an ongoing program, each **55** offers a story of modern life.

David Goldblatt (b.1930) began photographing in the 1960s. Since then, he has produced a body of work that is a fascinating study of life in South Africa during and after apartheid. His images, which have been described as 'acute in historical and political perception', reveal the system's origins, complexities and nuances.

Lesley Lawson has worked for non-governmental organizations in South Africa as a photographer and writer. Since 1990 she has worked in television, producing and directing current affairs films and documentaries.

Phaidon Press Limited
Regent's Wharf
All Saints Street
London N1 9PA

Phaidon Press Inc.
180 Varick Street
New York NY 10014

www.phaidon.com

First published 2001
©2001 Phaidon Press Limited

ISBN 0 7148 4051 3

Designed by Julia Hasting
Printed in Hong Kong

A CIP record of this book is available from the British Library. All rights reserved. No part of this publication may be reproduced, stored in a retrieval system or transmitted in any form or by any means, electronic, mechanical, photocopying, recording or otherwise, without the prior permission of Phaidon Press Limited.